John W. Coffey

with the assistance of David W. Wood

North Carolina Museum of Art

Contemporary Abstract Art from The Haskell Collection

Editor: Viki Balkcum
Designer: Barbara Wiedemann
Production Assistant: Phyllis Leistikow
Printer: The Stinehour Press, Lunenburg, Vermont

Cover: catalogue number 15 Back cover: catalogue number 19

The North Carolina Museum of Art, Lawrence J. Wheeler, Director, is an agency of the
North Carolina Department of Cultural Resources, Betty Ray McCain, Secretary. Operating support is provided
through state appropriations and generous contributions from individuals, foundations, and businesses.

ISBN: 0–88259–981 Library of Congress catalogue number: 98–068649

Published on the occasion of the exhibition
Sign and Gesture: Contemporary Abstract Art from The Haskell Collection,
organized by the North Carolina Museum of Art.

EXHIBITION ITINERARY

North Carolina Museum of Art
Raleigh, North Carolina
March 21–June 13, 1999

The Cummer Museum of Art and Gardens
Jacksonville, Florida
June 23–October 3, 1999

Knoxville Museum of Art
Knoxville, Tennessee
October 22, 1999–February 13, 2000

Birmingham Museum of Art
Birmingham, Alabama
March 5–May 21, 2000

Funding for the exhibition and catalogue has been provided by The Haskell Company.

Contents

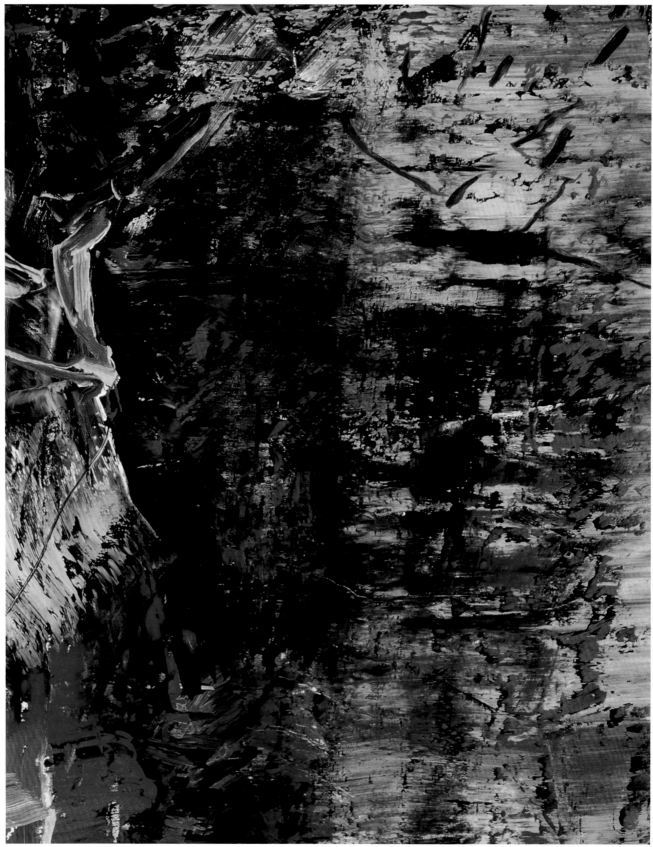

Detail: Gerhard Richter, *Untitled (613–3)*, cat. no. 20.

Director's Foreword

When The Haskell Company, one of the nation's largest design-build firms, opened a major corporate office in Raleigh, rumor reached us of the importance of the company's collection of contemporary art. Ever suspicious of art hype, our curator John Coffey and I decided to pay a call on company president Preston Haskell at his headquarters in Jacksonville, Florida. Our usual sang-froid soon was tempered by admiration for this collector's keen eye and a pattern of making bold, ambitious acquisitions. We found, in fact, a superb collection which had at its heart the substance of a fine special exhibition.

Sign and Gesture: Contemporary Abstract Art from The Haskell Collection, which the North Carolina Museum of Art has had the privilege of organizing, will now be seen by the public in Raleigh-Durham, Jacksonville, Birmingham, and Knoxville. We are grateful to our friend Preston Haskell for readily agreeing to the exhibition, and to The Haskell Company for supporting fully the costs related to its organization, presentation, and publication.

Also, we would like to acknowledge the enthusiastic support and cooperation of the institutions participating in the tour of the exhibition: Gail A. Trechsel, Director, and David Moos, Curator of Paintings, Sculpture, and Graphic Arts, Birmingham Museum of Art; Kahren J. Arbitman, Director, and the late Mary F. Linda, Associate Director and Chief Curator, Cummer Museum of Art and Gardens; and Richard I. Ferrin, President, and Stephen C. Wicks, Curator, Knoxville Museum of Art.

We hope that in days of waning corporate interest in building important art collections the example of The Haskell Company will inspire a renewed interest in making the great achievements of human artistic creativity a vital part of the American workplace.

LAWRENCE J. WHEELER
Director, North Carolina Museum of Art

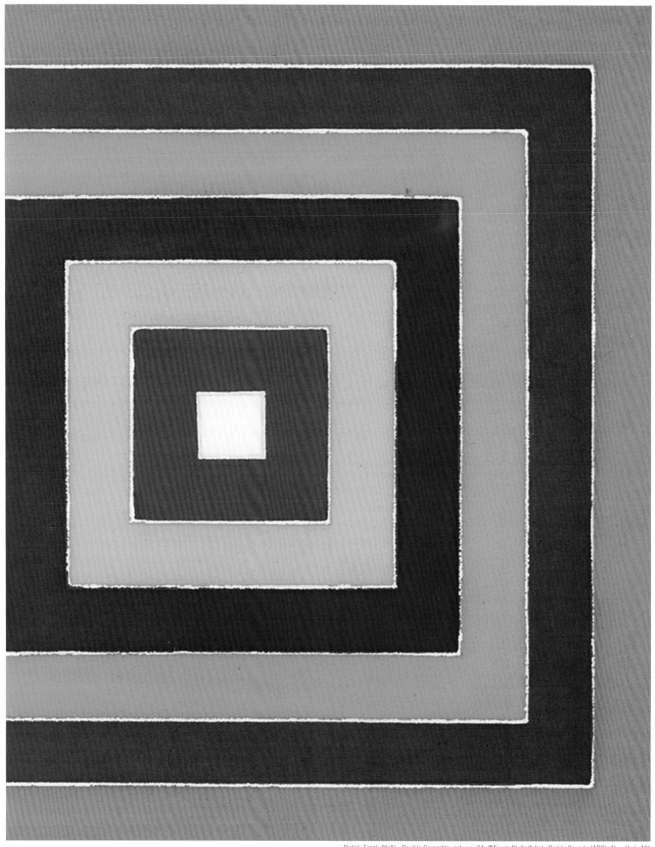

Detail: Frank Stella, *Double Scramble*, cat. no. 24. ©Frank Stella/Artists Rights Society (ARS), New York, NY

Collector's Statement

The Haskell Collection has evolved over the past thirty years from two strong and complementary dynamics. The first is my personal love for the energy, mystery, and excitement of abstract art, a passion that is often as difficult to rationalize as the art itself. Second is my personal conviction as to the role that art can play in an environment such as that of The Haskell Company.

My earliest purchases of contemporary art were placed rather equally at our offices and my home and periodically rotated between them, a pattern which has continued successfully to date. Thus I am fortunate to be surrounded by art both day and night and to share that experience with colleagues, friends, and the broader public in both venues.

Over the years it also became clear that works of art have a powerful effect in our workplace. Art stimulates our minds and spirits, making us more imaginative and creative— which is particularly appropriate to an organization which deals in designs, ideas, and concepts. It sends a strong message to visitors and external constituents that we value creativity. And it complements our leadership in supporting the arts throughout our community and region.

Thus I eagerly accepted the North Carolina Museum of Art's invitation to share a portion of the collection for a touring exhibition which might further heighten awareness of corporate art and the part it plays in the workplace and beyond. It is my hope that this tour will demonstrate that corporate collections exist not just for visual enjoyment, but are powerful resources for motivation and communication as to the role of beauty and creativity in our personal and business lives.

PRESTON H. HASKELL
President, The Haskell Company

1

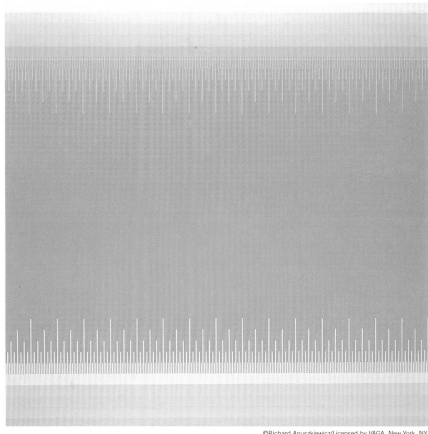

Catalogue of the Exhibition

ABBREVIATIONS:

Cummer 1992
 Jacksonville, Fla., Cummer Gallery of Art,
 *Abstract Expressionism: The Haskell
 Collection*, April 17–June 28, 1992.

Haskell 1997
 The Haskell Collection, Jacksonville,
 Fla., privately published, 1997.

JIA 1998
 Jacksonville, Fla., Jacksonville International
 Airport, Haskell Gallery, *Works on Paper
 from The Haskell Collection*, September 11–
 November 1, 1998.

1.

Richard Anuszkiewicz

American, born 1930

Burnt Orange, 1975

Acrylic on canvas
40 x 40 in. (101.6 x 101.6 cm.)

REF.: Haskell 1997, listed 54, illus. 9.
EXH.: Cummer 1992, no. 25, illus.

Richard Anuszkiewicz's paintings inquire into the physical and psychological foundations of perception, examining under tightly controlled conditions the "behavior" of color, line, and shape. Color is paramount. Using the sparest of means, the artist designs striking statements, easily comprehended yet subtle enough to intrigue the eye. His strategy is to pare down the content of the image, subjecting it to a strict geometric regime. Readily admitting that his work is "almost architectural in technique," Anuszkiewicz utilizes compositions of clear, repetitive structures regulating colors of exquisitely calibrated value and hue.[1] When properly deployed, the color and structure "induce a mirage" of vibrant motion and indeterminate space. Critics dubbed his paintings Retinal, or Optical, or simply "Op" Art, and in the 1960s Anuszkiewicz found himself in the forefront of a sensational, if short-lived, art movement.

Burnt Orange is one of a large series of paintings, executed in the mid-1970s, each picture titled by its dominant color. The compositions are variations of the same elements: bands of unblended color, precisely laid down, their edges optically blurred and agitated by lines resembling the seriated markings on a ruler. Though insistently abstract, these paintings in their horizontal format and soft gradations of color can suggest expansive landscapes (or seascapes). In fact, the artist has discussed these paintings in terms of their "atmosphere" and "climate": "you see systems, groups of colors, that function to create a total environment."

1 All quotes taken from artist interview with Gene Baro, in *Richard Anuszkiewicz: Recent Paintings*. New York, Andrew Crispo Gallery, 1975, n.p.

2

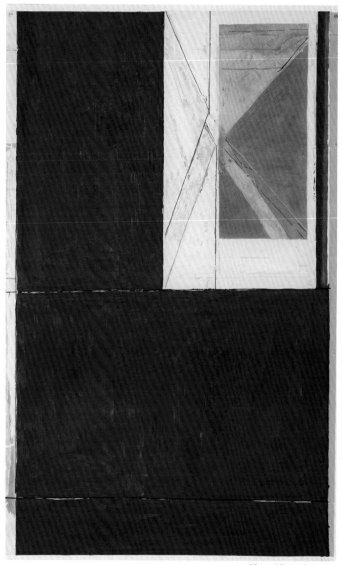

2.

Richard Diebenkorn

American, 1922–1993

Blue, 1984

Woodblock print
Sheet: 42 ¼ x 27 in. (107.3 x 68.6 cm.)
Image: 40 ⅛ x 25 in. (101.9 x 63.5 cm.)
Published by Crown Point Press,
Oakland, California
Edition: 19/200

REF.: *Print Collector's Newsletter* 15
(July/August 1984), 104.
EXH.: JIA 1998.

In mid-career and after a long period of vigorous realism, Richard Diebenkorn returned to abstract painting, initiating a brilliant succession of pictures known collectively as the Ocean Park series. These paintings and related drawings and prints exhibit a tension between impulsive feeling and a patient disposition to order and balance. The geometric structure of drawn lines and overlapping planes of color is intuitive rather than precise and reveals the artist correcting, adjusting, at times groping his way towards a formal and mindful tranquility. Most striking about Diebenkorn's abstractions is the quality of space and light. Even when enclosed or partitioned, the space remains expansive, elusive, and as welcoming as the sea's horizon. The color, too, so suggestive of the clear, somewhat chill light of the Pacific Coast, conveys a deep and moving experience of place.

Blue is a classic Ocean Park composition, its deliberate architecture dominated by blocks of "Diebenkorn Blue." Apart from its aesthetic pleasures, the print is remarkable for its technical virtuosity, indebted to the 400-year-old tradition of the Japanese *ukiyo-e* woodcut. Diebenkorn first created the design as a gouache painting. It served as a model for Japanese artisans who analyzed the image into eleven separate colors and cut printing blocks for each color. Inks were carefully mixed and printed thinly to approximate the painterly quality of the original gouache. Inevitably, adjustments were made, all under the artist's supervision. The resulting print is not so much a reproduction as a translation of the painting.

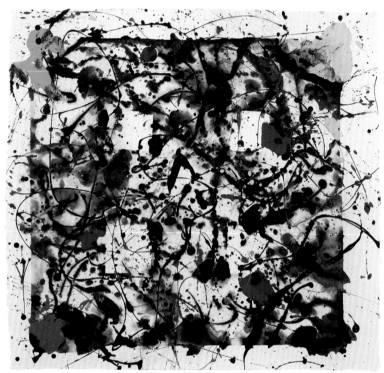

3.

Sam (Samuel Lewis) Francis

American, 1923–1994

Untitled (SF83–103), 1983

Acrylic on paper
36 ½ x 36 ½ in. (93.0 x 93.0 cm.)

REF.: Michel Waldberg, Sam Francis,
Metaphysics of the Void, Toronto,
Moos Book Pub., 1987, illus.
[with image reversed] 104; Haskell
1997, listed 54, illus. 17.
EXH.: New York, André Emmerich
Gallery, February 1984; Cummer
1992, no. 22, illus.

Sam Francis's art is exuberantly cosmopolitan. Although his signature technique of dripping and spattering paint aligns him with New York Abstract Expressionism, he has drawn equivalent inspiration from the late water lily murals of Monet and Japanese calligraphic painting, while his clear, vivid colors owe much to the Pacific light of his native California. For Francis, gesture, quick and audacious, is the intuitive response of a mind open to the world about it. And "color is a firing of the eye."[1]

Untitled, 1988–89 is a balance of oppositions: two broad, horizontal pools of sea green and blue, a red daub weighed against a daub of violet. These forms are suspended within the void of the canvas by a web of trailing paint. Without specificity, Francis conveys a vivid, joyful sensation of nature: the tidal wash of water and the spark and flicker of sunlight.

Untitled, 1983 is more remote in its reference. Here Francis presents a simple motif—an off-centered square—as a focus for contempla-

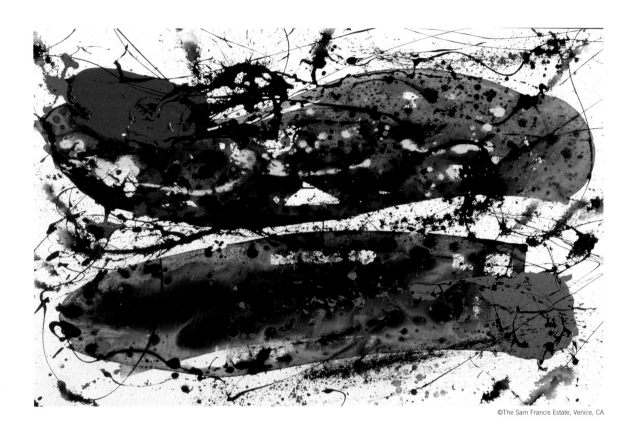

©The Sam Francis Estate, Venice, CA

4.

Sam (Samuel Lewis) Francis
American, 1923–1994
Untitled (SFP88–205), 1988–89

tion. Yet the square barely maintains its integrity. Loosely formed out of seemingly random jots and wisps of paint, it hovers in an unlimited space, more energy than matter. Or perhaps the square should be read as a void, an aperture opening onto a cosmos of frenzied yet strangely stable disorder. Such a vast interpretation is encouraged by the artist, who once asserted that his paintings are all about time: "Time which is instantaneous and simultaneous, Time which has no dimension, Time which is always spreading."[2]

Acrylic on canvas
48 x 72 in. (121.9 x 182.9 cm.)

REF.: Gregory Galligan, "Creative Leap-Frogging," *Art International* 9 (Winter 1989), 9; G. Burns, "Sam Francis," *Art Review* 41 (July 14, 1989), 532–33; Elizabeth Hayt-Atkins, "Sam Francis," *Art News* 88 (November 1989), 163; Haskell 1997, listed 54, illus. 16.
EXH.: New York, André Emmerich Gallery, *Sam Francis: New Paintings*, February 2–25, 1989; Basel, Switzerland, *20th International Art Fair*, June 14–19, 1989.

1 Pontus Hulten. *Sam Francis.* Bonn, Kunst und Ausstellungshalle der Bundesrepublik Deutschland, 1993, p. 37.
2 Jan Butterfield. *Sam Francis.* Los Angeles, Los Angeles County Museum of Art, 1980, p. 7.

through the personal.—Robert Motherwell[1] Abstract is not a style. I simply want to make a surface work. This

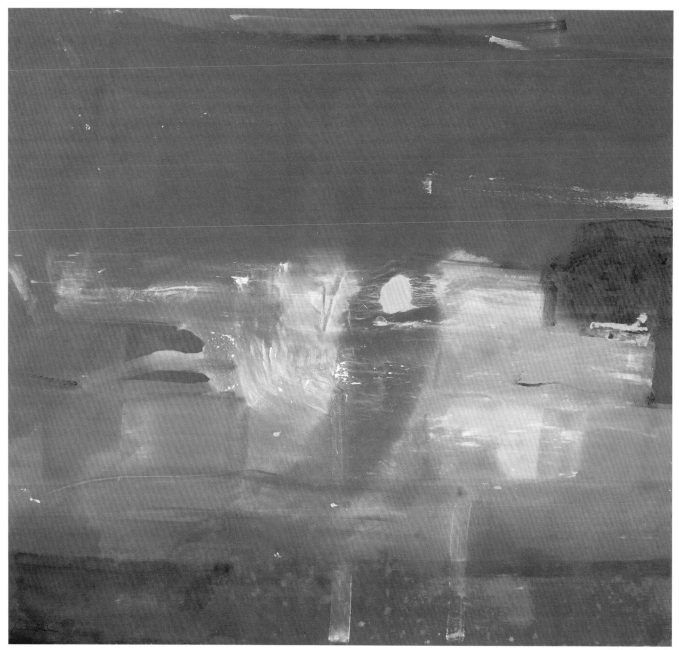

5

5.

Helen Frankenthaler

American, born 1928

Belfry, 1979

Acrylic on canvas
82½ x 86½ in. (208.9 x 219.7 cm.)

REF.: Jon R. Friedman, "Helen
Frankenthaler," *Arts Magazine* 54
(January 1980), 39; Nina French-Frazier,
"Helen Frankenthaler," *Art International* 23
(January/February 1980), 46–48; Valentine
Tatransky, "Helen Frankenthaler," *Flash Art*
(January/February 1980), 26; Haskell 1997,
listed 54, illus. 19.

EXH.: New York, André Emmerich Gallery,
Helen Frankenthaler: New Paintings,
November 3–28, 1979, illus.; Cummer
1992, no. 24, illus.

Helen Frankenthaler's painting is informed by a firm faith in her intuition and experience, a passionate engagement with the visual world, and a critical appreciation of art history and her place in it. The artist has aptly described her paintings as "explosive landscapes, worlds and distances, held on a flat surface."[1] The lyrical power of her pictures owes much to the technique of staining the raw canvas with broad swaths of dilute paint, reproducing the evanescent effects of watercolor, but on a far grander scale. For Frankenthaler, it is the psychological tension between illusion and reality—perceived space and actual flatness—that activates painting and compels consideration of the very nature of painting and the uncertainty of what meets the eye. According to Frankenthaler,

"part of the nuance and often the beauty or the drama that makes a work, or gives it life…is that it presents such an ambiguous situation of an undeniably flat surface, but on it and within it an intense play and drama of space, movements, light, illusion, different perspectives, elements in space."[2]

Belfry is a quiet meditation, a nearly formless picture of shifting marine light and shadow reminiscent, perhaps, of the sea cloaked in mist. The overall mood is subdued, pensive—elegiac. Colors are muted, the paint swept in languorous strokes that suggest, but never state, a subject. The illusion of transience and of vast, beckoning space is irresistible. What is there and what is not equally engage the imagination.

1 Patterson Sims. *Whitney Museum of American Art: Selected Works from the Permanent Collection.* New York, W.W. Norton, 1985, p. 165.
2 Cindy Nemser. "Interview with Helen Frankenthaler." *Arts Magazine* 46 (November 1971), p. 54.

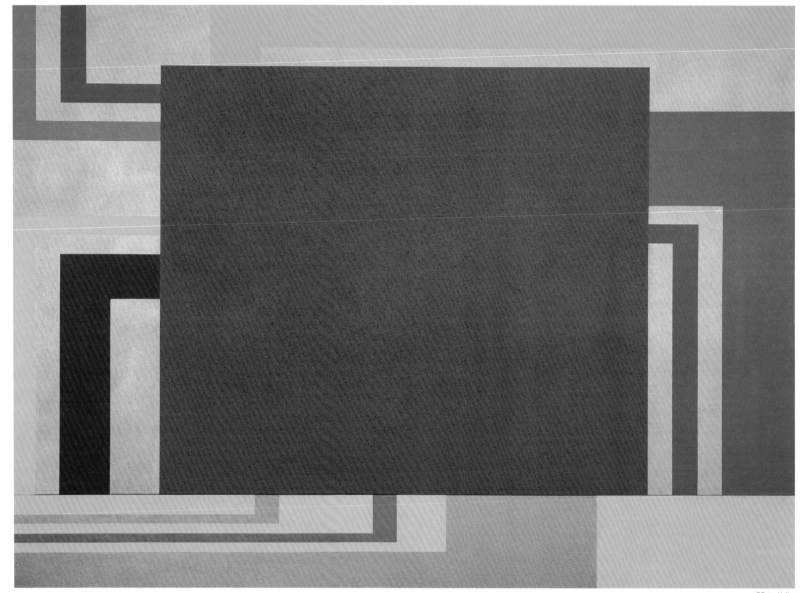

©Peter Halley

6

6.

Peter Halley

American, born 1957

Intruder, 1994

Day-glo acrylic, metallic acrylic,
acrylic, and Roll-A-Tex on canvas
88½ x 110½ in. (224.8 x 280.7 cm.)

EXH.: Dallas, Tex., Dallas Museum of Art,
Encounters: Peter Halley, January 28–
April 2, 1995, illus. cover.

Heavily steeped in post-modernist aesthetic and social theory, Peter Halley insists that his strictly ruled and dissonantly colored paintings constitute more than a hip update of geometric abstraction. They also pose a trenchant, if somewhat oblique critique of late 20th-century society, its foibles and obsessions with order and authority. Halley emphatically denies art any transcendence or universality—romantic fancies claimed by previous generations of abstract artists. Halley's artist is neither prophet nor priest, but activist philosopher, whose mission is to examine and explicate the conditions of a globalized, metropolized, post-industrial society.

Halley contends that "all the social is being transferred onto the electromagnetic digital grids of the computer…The computer chip becomes a universal gateway through which everything must pass."[1] Technology in the form of microcircuitry is the organizing principle for many of his compositions, including *Intruder*. Here, the central, dominant mauve rectangle, like a computer chip, is fixed within a network of color-coded "conduits" (Halley's term). And yet, despite its impersonal reference to technology, *Intruder* is unmistakably and sensually a painting, the work of an artist mindful of Mondrian and the whole heritage of geometric abstraction, and involved in traditional art concerns. The forms and colors are carefully calibrated to achieve both balance and dynamic play. Though the focus is on the block of purple, the eye does not rest, but orbits the edge. The artist, too, surprises with the surface textures, some areas built up of many layers of paint.

1 Peter Halley. "Notes on Abstraction." *Arts Magazine* 61 (June/Summer 1987), p. 39.

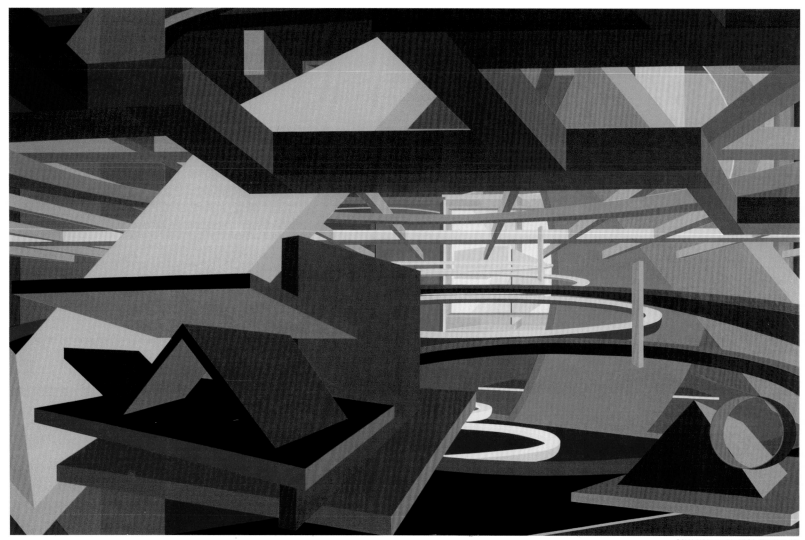

7

7.

Al Held

American, born 1928

Pan North VIII, 1986

Acrylic on canvas
72 x 108¾ in. (182.9 x 276.2 cm.)

REF.: *John Berggruen Gallery*, San Francisco,
Cal.: John Berggruen Gallery, 1986, illus. 42;
Kenneth Baker, "Dreamlike Images and
Vision," *San Francisco Chronicle*, April 29,
1986; Haskell 1997, listed 54, illus. 21.
EXH.: San Francisco, Cal., John Berggruen
Gallery, *Al Held: Recent Paintings*, April 16–
May 17, 1986.

Al Held's ambition has been nothing less than "to reinvent the whole abstract language [of painting]."[1] In the 1960s and 1970s, he defied the flat, minimalist aesthetic that dictated much of American abstraction, explaining: "I got frustrated at the notion of paintings getting simpler and simpler, so I developed this appetite for complexity: I wanted to put stuff back *into* my work. That's where the illusionistic space came in…"[2] Held's startling manipulations of pictorial space launch the viewer into a labyrinthine universe of crisp, abstract volumes. It is as if Mondrian's pure and serene geometry was somehow violently shattered and its fragments cast adrift in weightless space. In each picture the artist struggles to recollect these shards and restore at least a provisional harmony, if not purpose, to the whole.

The dizzying convolutions of space and "Italian" color in *Pan North VIII* derive from Held's study of Roman Baroque art and architecture. Nothing is as it seems. The various forms, apparently rationally disposed in space, are proved upon closer inspection to obey multiple and contradictory systems of perspective. Also, as in many of his "Roman" paintings, the artist heightens the mystery of the picture with theatrical lighting: the eye maneuvers through a dark and constricted foreground toward a light and relatively open distance. "The forms," Held asserts, "are a series of signs, or numbers, but it's how they come together and go apart that's interesting. It's not geometry, it's algebra. It's the equations these things make that are important."[3]

1 Nancy Grimes. "Al Held: Reinventing Abstraction." *Art News* 87 (February 1988), p. 104.
2 Stephen Westfall. "Then and Now: Six of the New York School Look Back." *Art in America* 73 (June 1985), p. 121.
3 Grimes, p. 109.

8

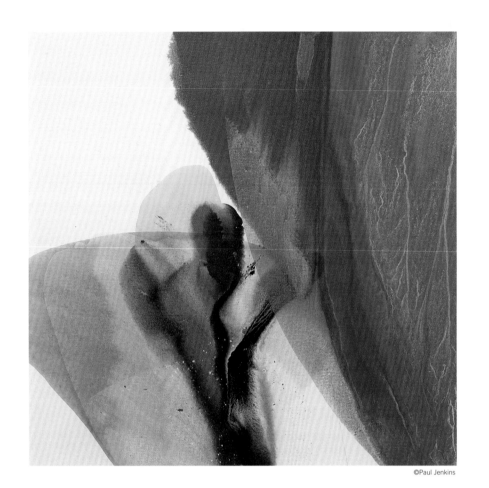

©Paul Jenkins

8.

Paul Jenkins

American, born 1923

Phenomena Spanish Cape, 1975

Acrylic on canvas
34 x 34 in. (86.4 x 86.4 cm.)

REF.: Haskell 1997, listed 54.
EXH.: Cummer 1992, no. 18, illus.

Paul Jenkins is an ardent believer in the power of abstract art to transform consciousness. He deploys color and light in pictorial space in the hope of visualizing what might be termed the spiritual in art. According to the artist, "surrounding all that is familiar to us there is something elusive and unknown, and it's this unknown that I try to uncover by approaching it in an indirect way." Jenkins further states that "our luminous world is caught in refraction, in interpenetration... I want to give the feeling that what happens on the canvas was taken from something more vast..."[1]

Phenomena Spanish Cape is composed of graceful veils of translucent color, billowing as if stirred by air. Space is imaged by this translucency. The elegance of the image masks the artist's accomplished technique. Jenkins paints by pouring thinned acrylic paint onto a flat canvas. By gradually tilting the canvas he guides—but only just—the flow of color across the fabric surface. Together with other Color Field artists Helen Frankenthaler and Morris Louis, Jenkins accepts the element of chance as inherent in this technique. What he gives up in control, he gains in surprise.

1 Artist conversation with Michel Butor. Quoted in Gilles Néret, "Le Diable et Le Bon Dieu." *Connaissance des Arts* 423 (May 1987), p. 102. Translation by David W. Wood.

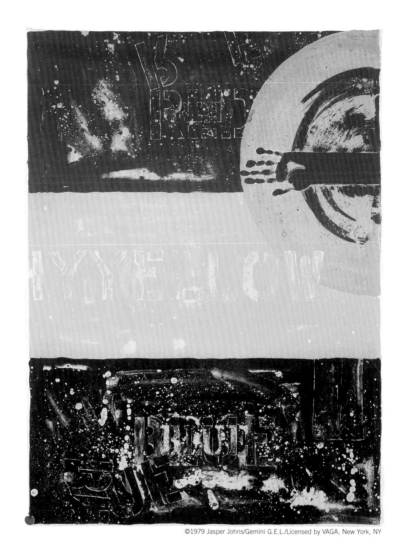

9.

Jasper Johns

American, born 1930

Periscope I, 1979

Lithograph
Sheet and image: 50 x 36 in.
(127.0 x 91.4 cm.)
Published by Gemini G.E.L.,
Los Angeles, California
Edition: 8/65

REF.: Gemini cat. no. 840; Ruth E. Fine,
Gemini G.E.L.: Art and Collaboration,
Washington, D.C., National Gallery of Art,
1984, no. 72, illus.; Riva Castleman,
Jasper Johns: A Print Retrospective,
New York, Museum of Modern Art, 1986,
19, 45, 46, illus. 130; Richard S. Field,
The Prints of Jasper Johns, 1960–1993,
West Islip, N.Y., Universal Limited Art
Editions, 1994, no. 200, illus.; Haskell
1997, listed 54, illus. 26.

EXH.: JIA 1998.

Jasper Johns's art is of such refined perplexity as to defy ready analysis. Almost perversely resistant to straightforward statement, Johns distracts attention from the work's ostensible subject by presenting it as an intriguing and beautifully crafted, even sensual object. Its physical presence always overrules the apparent absence of clear intention.

Johns's prints generally recycle imagery first worked out in paintings. *Periscope I* is based on a 1963 painting *Periscope (Hart Crane)*. The title refers to a passage in Hart Crane's poem "Cape Hatteras":

...while time clears
Our lenses, lifts a focus, resurrects
A periscope to glimpse what joys or pain
Our eyes can share or answer—then deflects
Us, shunting to a labyrinth submersed
Where each sees only his dim past reversed...[1]

The poem, the painting, and the print meditate upon the elusiveness of perception and memory. Associations are tenuous, and many are presumably "submersed," beyond recovery. Colors are specifically named, prompting the question: Does the word signify more than the color itself? An arm, like a clock hand, sweeps an arc across the surface. The arm, or rather the print of an arm, substitutes for the absent figure. Further complicating interpretation, the artist relates the arm to the drowned (and therefore absent) Hart Crane. Time and loss, then, ground the image.

1 Brom Weber, ed. *The Complete Poems and Selected Letters and Prose of Hart Crane.* Garden City, Anchor Books, Doubleday Co., 1966, p. 88.

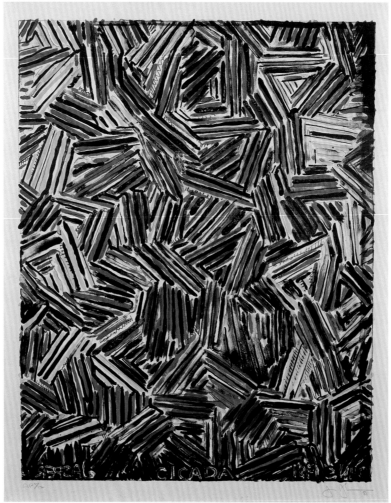

10

10.

Jasper Johns

American, born 1930

Cicada, 1981

Lithograph
Sheet and image: 35 x 26 in.
(88.9 x 66.0 cm.)
Published by Gemini G.E.L.,
Los Angeles, California
Edition: A.P. 5/12

REF.: Gemini cat. no. 923; Richard S. Field,
The Prints of Jasper Johns, 1960–1993,
West Islip, N.Y., Universal Limited Art
Editions, 1994, no. 213, illus.; Haskell 1997,
listed 54, illus. 25.

EXH.: Cummer 1992, no. 26; JIA 1998.

NOTE: Included in portfolio *Eight Lithographs
to Benefit the Foundation for Contemporary
Performance Arts, Inc.*

Cicada derives from a 1979 water-
color of the same title, though the
color scheme of the print is more
somber. Beginning in 1972 and
continuing for more than a decade,
Johns worked variations on a crazy-
quilt pattern of hatch marks. He
noted that the pattern "had all
the qualities that interest me—
literalness, repetitiveness, an
obsessive quality, order with
dumbness, and the possibility
of complete lack of meaning."[1]

1 Sarah Kent. "Jasper Johns: Strokes of Genius." *Time Out* (London), December 5–12, 1990; reprinted in Kirk Varnedoe, ed., *Jasper Johns: Writings, Sketchbook Notes, Interviews*. New York, Museum of Modern Art, 1996, p. 259.

{26}

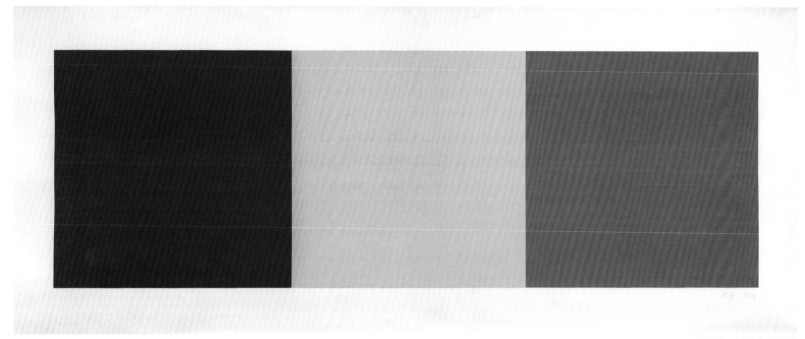

11

11.

Ellsworth Kelly

American, born 1923

Blue, Yellow and Red Squares, 1970–71

Screenprint
Sheet: 34 x 82 in. (86.4 x 208.3 cm.)
Image: 24 x 72 in. (61.0 x 182.9 cm.)
Published by Gemini G.E.L.,
Los Angeles, California
Edition: A.P. VIII

REF.: Gemini cat. no. 264; "Prints and
Portfolios," *Print Collector's Newsletter*,
1971, 35; Richard H. Axsom, *The Prints
of Ellsworth Kelly: A Catalogue Raisonné,
1949–1985*, New York, Hudson Hills Press,
1987, no. 73, illus.; Haskell 1997, listed 54.

Ellsworth Kelly has little interest in art that presumes to represent either the visual world or the inner being of the artist. He is interested in a mindful quality of seeing, a discriminating engagement of eye and mind that quickens awareness, even awakens the spirit. To that end, Kelly has stripped his art as far as possible of all outside (and inside) references, leaving himself only the bare necessities of form and color. He states plainly that "the form of my painting is its content. My work is made of single or multiple panels: rectangle, curved or square. I am less interested in marks on the panels than the 'presence' of the panels themselves."[1] Kelly's colors, though impersonal in application and precisely edged, can be warmly sensual: his reds are not paint-store reds nor his blues and yellows common varieties. Their juxtapositions too can be exquisitely lyrical.

Blue, Yellow and Red Squares repeats the primary colors of a 1966 painting, though reversing the sequence. In both print and painting, the colors are stated as three conjoined squares. Such a laconic, self-contained presentation encourages attention to the subtle interactions among the three colors and their variable relationships to the background field of the paper. Note, for instance, how each block of color appears to occupy a different depth in the fictive space of the paper.

1 "Notes of 1969." Reprinted in slightly revised form in Kristine Stiles and Peter Selz, eds., *Theories and Documents of Contemporary Art*. Berkeley, University of California Press, 1996, p. 92.

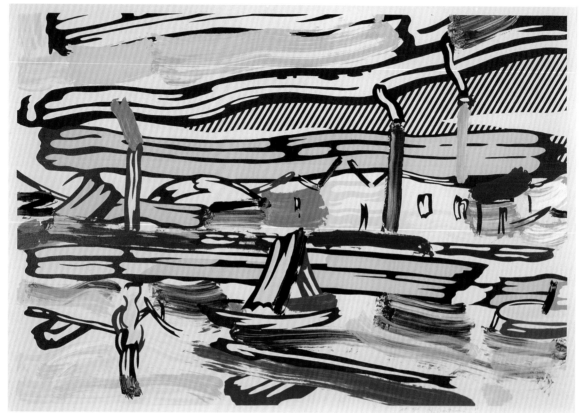

12

12.

Roy Lichtenstein

American, 1923–1997

The River (from Landscapes series), 1985

Lithograph, woodblock, and screenprint
Sheet: 40¼ x 55⁹⁄₁₆ in. (102.2 x 141.1 cm.)
Image: 37¼ x 52⁹⁄₁₆ in. (94.6 x 133.5 cm.)
Published by Gemini G.E.L.,
Los Angeles, California
Edition: A.P. 7/11

REF.: Gemini cat. no. 1256; Mary Lee Corlett, *The Prints of Roy Lichtenstein: A Catalogue Raisonné, 1948–1993*, New York, Hudson Hills Press, 1994, no. 214, illus.
EXH.: JIA 1998.

Roy Lichtenstein has a uniquely ironic relationship with the printed image. His earlier paintings, especially the icons of Pop Art from the 1960s, shamelessly crib both style and subject from comic books, magazine ads, and other popular and disposable sources. Turning to prints, he was effectively returning his images to their natural medium. Though his images cheerfully violate many of the hallowed conventions of Western art, Lichtenstein was always aware of the continuum of art history. In fact, much of his later work paid tribute to his artistic heroes, for instance, his numerous versions of Monet serial landscapes ("manufactured Monets") or Picasso still lifes, or Mondrian's grids.

Of course, in all of these homages, Lichtenstein teasingly casts doubt upon the sincerity or assigned importance of the work of art,

first by appropriating another's image or style, and then by rendering it in the sleek, graphic shorthand of commercial art. *The River*, one of a series of "painting size" landscape prints, presents a typical problem of interpretation. It is a Pop update of a recognizably Impressionist (or Expressionist?) landscape painting with a sailboat, factory, and cloud-strewn sky. The subject is not really the landscape, however, but the painting itself: not the art but the object. Lichtenstein simulates the jots and slashes of brushstrokes using two competing modes of representation, one realistic (executed in lithography and screenprinting), the other cartoonish (woodcut). The final, telling irony is that this "meditation" on the painterly act of painting takes place on a flat, printed sheet of paper— one of an identical edition of sixty.[1]

1 It should be noted that the print in The Haskell Collection is one of eleven artist's proofs, in addition to the published edition.

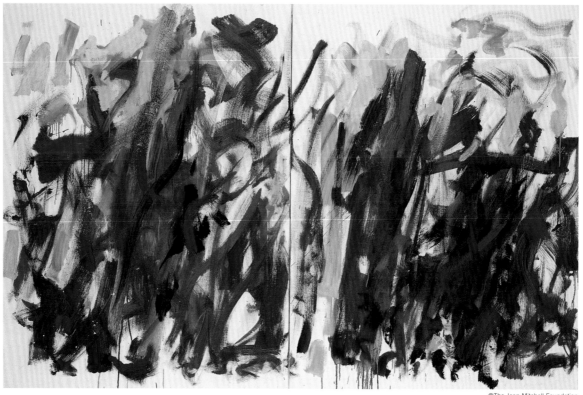

13

13.

Joan Mitchell
American, 1926–1992
Sunflowers, 1990

Oil on canvas
51 x 76½ in. (129.5 x 194.3 cm.)

REF.: Haskell 1997, listed 55, illus. 31.

Asked what she wanted from her painting, Joan Mitchell replied, "I don't set out to achieve a specific thing, perhaps to catch motion or to catch a feeling…I try to eliminate clichés, extraneous material. I try to make it exact. My painting is not an allegory or a story. It is more like a poem."[1] Mitchell spent the last two decades of her life in northern France, deriving the imagery in her paintings from the lush landscape surrounding her home in Vétheuil. There she developed a distinctive hybrid style that brought together the assertive

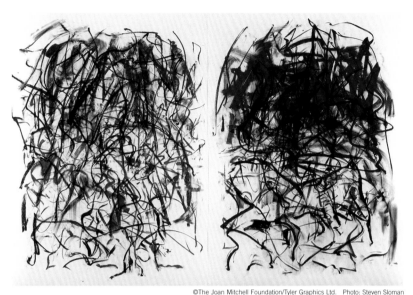

©The Joan Mitchell Foundation/Tyler Graphics Ltd. Photo: Steven Sloman

14

freedom and big city gesture of Abstract Expressionism with an Impressionist's palette and delight in nature. Not unjustly has Mitchell been called an "abstract impressionist."

Like Monet, Mitchell was enraptured by gardens and flowers, particularly sunflowers. She once admitted: "Sunflowers are something I feel very intensely. They look so wonderful when young and they are so very moving when they are dying." Sunflowers inspired many of the artist's late paintings and a series of related prints. Though by no means realistic, these works evoke the ecstatic life force of the flowers as recalled in moments of acute awareness. Mitchell held that "painting is the only art form except still photography which is without time…It never ends, it is the only thing that is both continuous and still…It's like one word, one image…" The artist frequently cast her images in diptych format, possibly to appropriate the sacredness of an icon, but also perhaps to reintroduce time—two simultaneous moments—into her still pictures.

14.

Joan Mitchell

American, 1926–1992

Sunflowers II (from the Sunflowers series), 1992

Lithograph, two sheets
Each sheet: 57 ¼ x 41 in.
(145.4 x 104.1 cm.)
Published by Tyler Graphics Ltd.,
Mount Kisco, New York
Edition: 32/34

REF.: Haskell 1997, listed 55, illus. 30.
EXH.: JIA 1998.

I All quotes from Yves Michaud. "Conversations with Joan Mitchell, January 12, 1986." *Joan Mitchell: New Paintings.* New York, Xavier Fourcade, 1986, n.p.

15

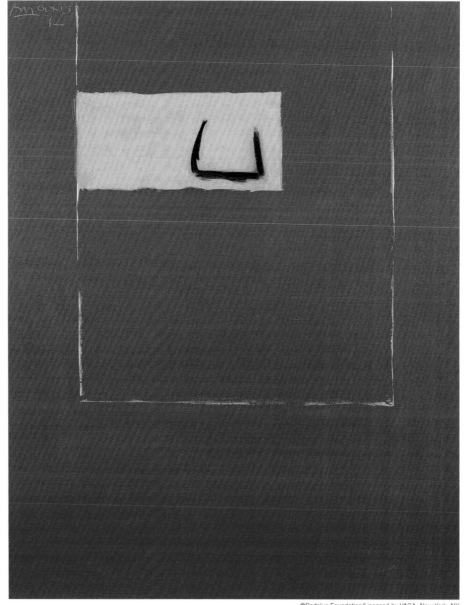

15.

Robert Motherwell

American, 1915–1991

Untitled (Red), 1972

Acrylic on canvas
71¾ x 54 in. (182.0 x 137.0 cm.)

REF.: Haskell 1997, listed 55,
illus. 33.

The New York School's resident poet/philosopher, Robert Motherwell understood abstract art as a "form of mysticism," a means by which the imagination might apprehend the unseen and universal. Motherwell never doubted that abstraction was the only valid mode for a painter in the modern world. When asked his approach to painting, the artist explained that

The game is not what things "look like."
The game is organizing, as accurately and
with as deep discrimination as one can, states
of feeling; and states of feeling, when generalized,
become questions of light, color, weight, solidity,
airiness, lyricism, sombreness, heaviness,
strength, whatever....[1]

No one played the "game" as gracefully or with as much intelligence as Motherwell.

Untitled (Red) is one of an extended series of paintings begun in 1967 and collectively titled Opens. The series is characterized by an emphasis on broad, freely brushed expanses of color and by the singular imposition of a U-shaped motif, which the artist identifies as a door or window: "an opening into an airy, rising world."[2] In this painting Motherwell hones a succinct, contemplative image, deftly balancing content with vacancy, and elegance with blunt statement. There is nothing extraneous, and what is left unexplained seems nevertheless right. The artist intentionally leaves open the question of whether the red field should be seen as a void or as a wall. Implicitly, he accepts both interpretations.

1 Stephanie Terenzio, ed. *The Collected Writings of Robert Motherwell.* New York, Oxford University Press, 1992, p. 179.
2 Artist interview with Irmeline Lebeer, 1973. Quoted in Clifford Ross, ed., *Abstract Expressionism: Creators and Critics: An Anthology.* New York, Abrams, 1990, p. 119.

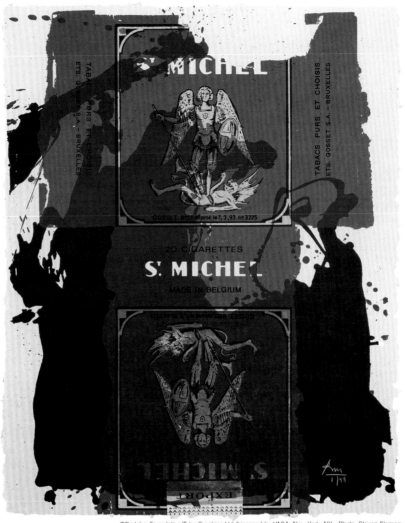

16

16.

Robert Motherwell

American, 1915–1991

St. Michael III, 1975–79

Lithograph and screenprint
Sheet and image: 41½ x 31½ in.
(105.4 x 80.0 cm.)
Published by Tyler Graphics Ltd.,
Bedford Village, New York
Edition: 22/99

REF.: Kenneth E. Tyler, *Tyler Graphics Ltd.:
Catalogue Raisonné, 1974–1985*, New York,
Abbeville Press, 1987, no. 398:RM17, illus.;
Dorothy C. Belknap, "Catalogue Raisonné,
1943–1984," in Stephanie Terenzio,
The Prints of Robert Motherwell, New York,
Hudson Hills Press, 1984, no. 206, illus.;
Dorothy C. Belknap, "Catalogue Raisonné
1943–1990," in Stephanie Terenzio,
The Prints of Robert Motherwell, New York,
Hudson Hills Press, 1991, no. 206, illus.;
Haskell 1997, listed 55, illus. 32.

Alone among the Abstract Expressionist painters of his generation, Robert Motherwell devoted serious and sustained attention to the making of prints. He was a thoughtful and prolific graphic artist whose prints possess much of the elegance, authority, and passionate humanity of his paintings.

St. Michael III is obviously indebted to Motherwell's extensive investigations in collage. Inspired by Surrealist practice, the artist would incorporate fragments of found images in his work, seeking associations both aesthetic and psychological. Here, Motherwell utilizes a wrapper torn from a pack of Belgian cigarettes. The wrapper, retrieved from the street or wastebasket, conveys a medley of connotations: urbanity, disposability, even religion (if one takes seriously the logo of the triumphant archangel). The artist screenprints a vastly enlarged image of the wrapper over a loosely brushed abstract design, allowing both elements to play off each other. Note, for instance, how the ragged contour of the brushed element formally mimics the top edge of the wrapper.

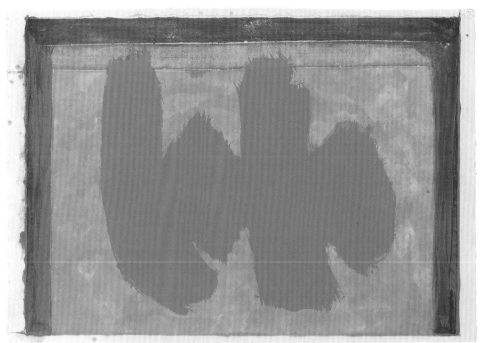

17

17.

Robert Motherwell

American, 1915–1991

Blue Elegy, 1987

Relief and lithograph
Sheet and image: 41½ x 57¾ in.
(105.4 x 146.7 cm.)
Published by Tyler Graphics Ltd.,
Bedford Village, New York
Edition: 12/30

REF.: Dorothy C. Belknap, "Catalogue
Raisonné 1943–1990," in Stephanie
Terenzio, *The Prints of Robert Motherwell*,
New York, Hudson Hills Press, 1991,
no. 347, illus.; Haskell 1997, listed 55,
illus. [image reversed] 34.

Though created in Motherwell's
final years, *Blue Elegy* continues the
artist's career-long series of Elegies,
in which he sought to convey in
purely abstract terms his sustained
meditation upon the tragic nature of
life. The principal motif—four stark
repetitive strokes, like the tolling of a
bell—is meant to stand in symbolic
lament for our moment on Earth.
In this context the deep blue of
the gesture seems almost wistful.

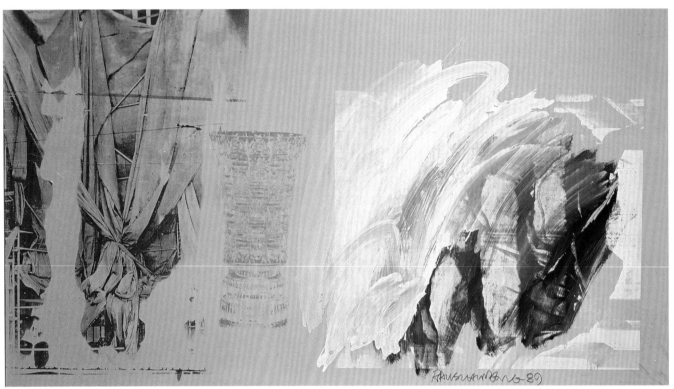

18

18.

Robert Rauschenberg

American, born 1925

Golden Chalice, 1989

Acrylic and transfer on aluminum
48 x 84 in. (121.9 x 213.4 cm.)

REF.: Haskell 1997, listed 55, illus. 35.
EXH.: Cummer 1992, no. 23, illus.

Robert Rauschenberg's art is fired by his omnivorous curiosity, quick wit, and buoyant optimism at the power of art to shape understanding. His explosive imagination recognizes no barrier between art and life: "I've always wanted my work to look more like what was going on outside the window than in the studio."[1] Salvaging images and artifacts cast up and out by our culture, and relentlessly arranging and rearranging this unpromising raw material, the artist divines surprising and often provocative associations. Nothing is out-of-bounds for Rauschenberg, and everything eventually finds its way into his work.

Golden Chalice presents a typical challenge to the viewer. The seemingly haphazard composition contains four disparate elements: photographic transfer images of (left to right) a cloth-draped scaffold; cut-glass vase; and an architectural detail, the last partially obscured by the fourth element, a brazenly artless swish of paint. The vase, or "chalice," positioned off-center, seems to mediate ritually between images. The meaning of that mediation remains a tantalizing enigma.

1 Donald J. Saff. "Conservation of Matter: Robert Rauschenberg's Art of Acceptance." *Aperture* 25 (Fall 1991), p. 26.

Sometimes I see it and then paint it. Other times I paint it and then see it. Both are impure situations, and

19

19.

Robert Rauschenberg

American, born 1925

Soviet/American Array II, 1988–90

Photogravure and collage
Sheet: 87¾ x 52¼ in. (222.8 x 132.7 cm.)
Published by Universal Limited
Art Editions, West Islip, New York
Edition: 36/55

REF.: Haskell 1997, listed 55, illus. 35.
EXH.: JIA 1998.

Rauschenberg's belief that art can provide a bridge between cultures led him in 1984 to launch the Rauschenberg Overseas Cultural Interchange (ROCI), a privately funded project "taking, making and exchanging art and facts around the world."[1] Following a lengthy visit to the Soviet Union, the artist created a series of large gravure prints, using photographs taken from American and Russian sources. Titled Soviet/American Array, the series afforded the artist the opportunity to make provisional sense of his impressions. In *Soviet/American Array II*, Rauschenberg cannot resist acknowledging a less altruistic instance of cultural interchange: the "First American Pizza in Moscow."

1 Robert Rauschenberg. "Tobago Statement," in *Rauschenberg Overseas Culture Interchange*. Washington, DC, National Gallery of Art, 1991, p. 154.

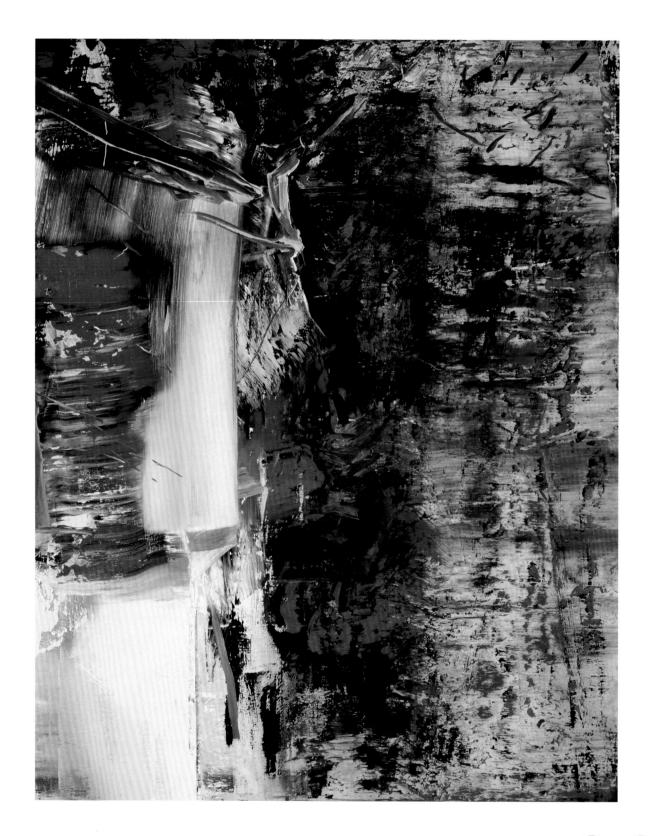

20

20.

Gerhard Richter

German, born 1932

Untitled (613–3), 1986

Oil on canvas
102½ x 79 in. (260.3 x 200.7 cm.)

REF.: Roberta Smith, "Art: At Two Galleries, Gerhard Richter Works," *New York Times*, Mar. 13, 1987, C31; Kay Larson, "Gerhard Richter," *New York Magazine* 20 (March 23, 1987), 70, 72; Ken Sofer, "Gerhard Richter," *Art News* 86 (Summer 1987), 201; Donald Kuspit, "Gerhard Richter," *Artforum* 25 (Summer 1987), 115–116; Klaus Ottman, "Gerhard Richter," *Flash Art* 136 (October 1987), 97; Benjamin H. D. Buchloh, *Gerhard Richter*, Bonn, Kunst und Austellunghalle der Bundesrepublik Deutschland, 1993, vol. 3 (catalogue raisonné), no. 613–3, illus.; Haskell 1997, listed 55 [incorrectly dated 1968], illus. 37.

EXH.: New York, Sperone Westwater Gallery, *Gerhard Richter: Paintings*, March 5–April 4, 1987, illus.; Stockholm, Moderna Museet, *Implosion: A Postmodern Perspective*, October 24, 1987–January 10, 1988, no. 76, illus.

Defying convention, Gerhard Richter refuses to conform to one particular style of painting. Declaring all styles equally valid—and invalid—Richter moves freely between abstract and representational modes. However, his open-ended series of abstractions, marked by visceral, seductive color and a decisive, almost reckless technique, constitutes his major achievement. These images are deliberately divorced from our experience of the world and, instead, present an alternative reality of color and spatial relationships sensible only within the confines of the picture. The artist's painting process is studiously unrehearsed. It depends upon a continuous, unpredictable, and changing dialogue with the image: "I always begin with the intention of obtaining a closed picture, with a properly composed motif. Then… I proceed to destroy this intention piece by piece, against my own will almost, until the picture is finished—that is, until it has nothing left besides openness."[1]

This large untitled canvas is the very model of controlled frenzy. The surface is a dense, bewildering accumulation of actions and responses. The artist's struggle—his slips and anxious second thoughts—is bared for all to see. That evident struggle contributes mightily to the emotional power of the painting. Within the picture, space is handled willfully. Depth cues are countermanded by the physical reality of the paint, brushed, smeared, and scraped on the canvas. The welter of gestures never coalesces in any form or object (except perhaps the plunging cascade of light on the left). Rather, they seem the visual traces of impulsive, even ecstatic motion.

1 Benjamin H. D. Buchloh. "Interview with Gerhard Richter," in *Gerhard Richter: Paintings*. London, Thames and Hudson, 1988, p. 27.

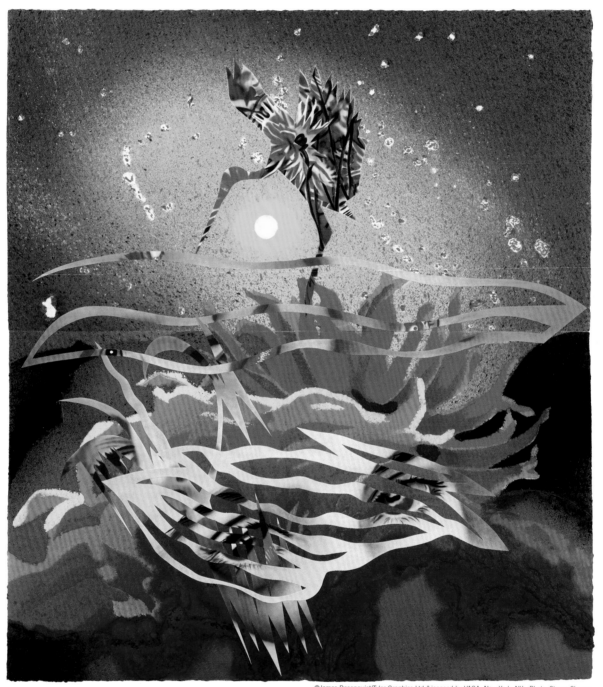

21

21.

James Rosenquist

American, born 1933

The Bird of Paradise Approaches the Hot Water Planet (from Welcome to the Water Planet series), 1989

Colored and pressed paper pulp, lithograph, and collage; two sheets

Top sheet: 46½ x 84½ in. (118.1 x 214.6 cm.)

Bottom sheet: 50½ x 84½ in. (128.3 x 214.6 cm.)

Published by Tyler Graphics Ltd., Mount Kisco, New York

Edition: 22/28

The Jacksonville Museum of Contemporary Art, Gift of Preston H. Haskell

REF.: Judith Goldman, *James Rosenquist: Welcome to the Water Planet and House of Fire, 1988–1989*, Mount Kisco, N.Y., Tyler Graphics Ltd., 1989, 22–23, illus.; Constance W. Glenn, *Time Dust: James Rosenquist: Complete Graphics: 1962–1992*. New York, Rizzoli, 1993, no. 214, illus.

Taking his cue from American consumer culture, James Rosenquist sees himself as much an advertiser as an artist, generating images that scream for attention, that assault and batter the senses yet convey little more than the rude, boisterous energy of their delivery. Early in his career, he confessed to being "amazed and excited and fascinated about the way things are thrust at us, the way this invisible screen that's a couple of feet in front of our mind and our senses is attacked by radio and television and visual communications…"[1] Rosenquist develops his art out of fragmentary images, clipped from magazines, cropped and cut often beyond recognition, then assembled collage-like into loud, extroverted, and psychologically jarring compositions.

The Bird of Paradise Approaches the Hot Water Planet was the first in an extraordinary series of nine prints collectively titled Welcome to the Water Planet. According to the artist, the series grew out of his fantasies of space travel and his concern for the future survival of Earth, the "hot water planet." In this print, the vantage is from outer space. Wisps of cloud appear before a distant sun as a bird-like shape "alights" amid petals—or flames. Rosenquist generates such cosmic imagery out of mundane material: the clouds are shredded glamour close-ups of women's faces, and the "bird" takes its shape from the outline of two exotic Bird of Paradise blooms. The print itself is a technical tour de force. The background areas of petal and shadow are formed out of colored pulp paper, poured and sprayed over stencils. The "bird" and "cloud" shapes are lithographs, die-cut and collaged.

1 G. R. Swenson. "What is Pop Art?, Part 2" *Art News* 62 (February 1964), p. 63.

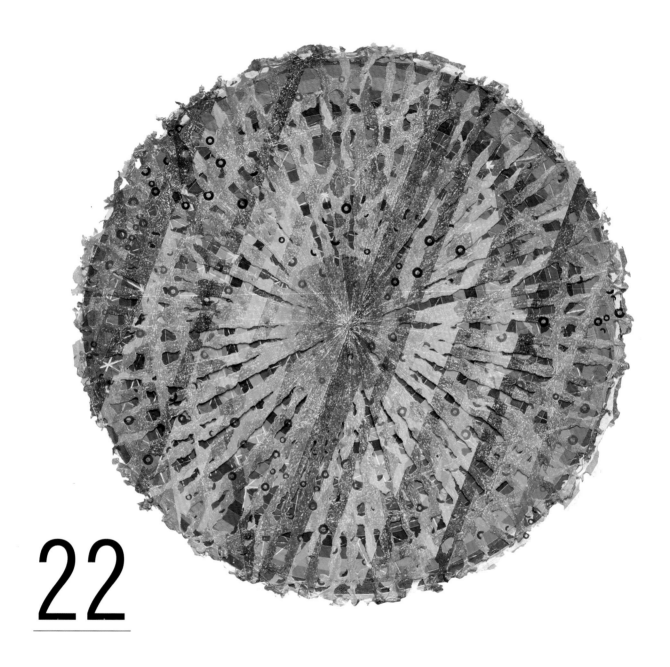

22

22.

Alan Shields

American, born 1944

Rain Dance Route (from The Raggedy Circumnavigation series), 1985

Relief, woodblock, stitching, and collage
Sheet and image: 47 in.
(119.4 cm.) diameter
Published by Tyler Graphics Ltd.,
Bedford Village, New York
Edition: 19/20

REF.: Ronny Cohen, *Alan Shields: Print Retrospective*, Cleveland, Ohio, Cleveland Center for Contemporary Art, 1986, no. 112; Kenneth E. Tyler, *Tyler Graphics Ltd.: Catalogue Raisonné, 1974–1985*, New York, Abbeville Press, 1987, no. 513:AS36, illus.; Haskell 1997, listed 55, illus. [mislabeled] 41.

Having once considered a career as a theater set designer, Alan Shields remains a truly theatrical artist, attuned to the surprise and dramatic potential of simple ideas and materials. The artist is best known for his two- and three-dimensional constructions of painted, dyed, and stitched canvas, tacked to the wall, suspended like a scrim, or stretched over armatures of basic geometric shapes. His work is certainly playful but never glib, charged as it is by a searching curiosity and an ambition to seize and animate any wall or room.

The print studio has long been a central arena for Shields's creativity, where he has relentlessly tested the expressive possibilities of new materials, techniques, and approaches. *Rain Dance Route* is one of seven astonishing prints collectively and whimsically titled The Raggedy Circumnavigation series. Circular in format, each print in the series is composed of multiple layers of handmade paper, including ten different lattice patterns designed by the artist. The various papers were printed, then sewn together with colored string. The result is a complex sculptural relief that does not conceal, but rather celebrates the method (and seeming madness) of its making. In *Rain Dance Route*, the density and contradictions of the accumulated structures and color systems create a loud, rhythmic image, implosive and explosive: a bebop mandala.

23

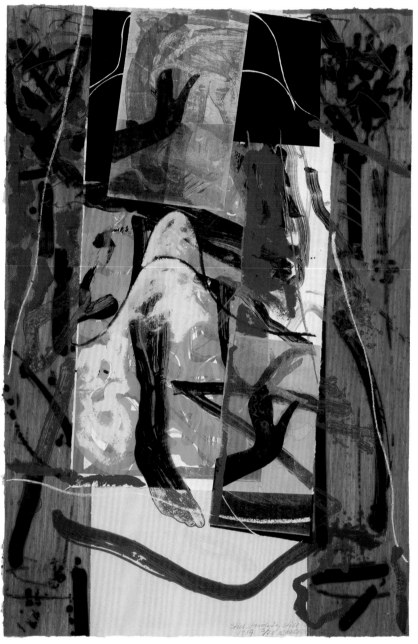

23.

Steven Sorman

American, born 1948

Still Standing Still, 1984–85

Relief, etching, woodblock,
lithograph, collage, with hand-coloring
Sheet and image: 66¼ x 43 in.
(168.3 x 109.2 cm.)
Published by Tyler Graphics Ltd.,
Bedford Village, New York
Edition: A.P. I

REF.: Mary Abbe Martin, *Steven Sorman:
Collage Prints and Monoprints*, Bedford
Village, N.Y., Tyler Graphics, 1985, 11,
illus.; Kenneth E. Tyler, *Tyler Graphics Ltd.:
Catalogue Raisonné, 1974–1985*, New York,
Abbeville Press, 1987, no. 534:SS18, illus.

Steven Sorman's paintings and prints are unabashedly gorgeous, rejoicing in the pleasure of opulent color and bold, exuberant drawing. Sorman describes his working method as "generally collage oriented."[1] He takes bits and pieces of images, combining and recombining them until a collective whole emerges. The artist notes that this improvisational method "gives me the opportunity to see 30 or 40 possibilities before choosing one." His most engaging works retain the spontaneity and playfulness of the process: the image as game played by an artist who blithely makes up the rules as he goes along. This sort of joyful gamesmanship is especially evident in Sorman's prints. Like Frank Stella, Sorman resists confining his graphic imagery within the technical limitations of traditional intaglio, woodcut, or lithographic processes. His prints are often bravura combinations of all of these, plus collage and hand-coloring, all laid down on handmade and oriental papers.

Still Standing Still is one of a series of monotype and editioned prints produced in 1984–85. For all the technical wizardry involved in its making, the image offers a casual intimacy, full of Sorman's ebullient brushwork and wry humor. The title refers to the partially embedded silhouette of a figure balancing on one leg in the center of the composition. This curious motif recurs in other prints in the series. Also recurring is the graceful outline of a hand, thumb pressed to forefinger, here repeated twice. Whatever private meaning these motifs may have for the artist, they primarily serve as witty design elements.

1 Ronny Cohen. "The Medium Isn't the Message." *Art News* 84 (October 1985), p. 80.

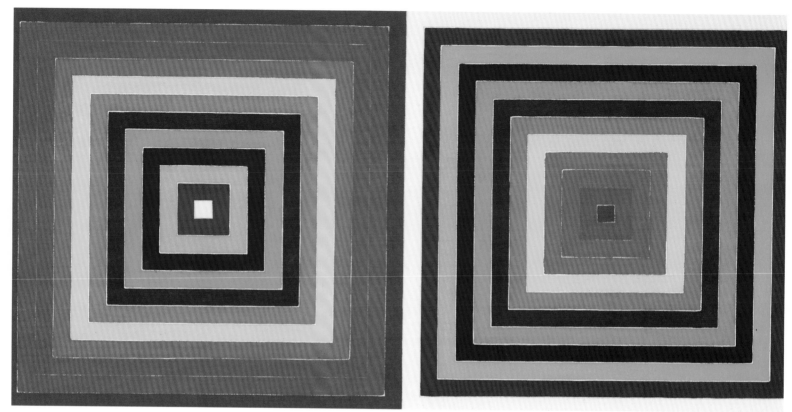

24

24.

Frank Stella

American, born 1936

Double Scramble, 1978

Oil on canvas

68⅞ x 138 in. (174.9 x 350.5 cm.)

REF.: Haskell 1997, listed 55, illus. cover.

"What you see is what you see," is Frank Stella's often quoted explanation of his art. As a young artist on-the-make, Stella categorically rejected Abstract Expressionism and its confessional, soul-wrenching claims to truth. Instead, he proposed an art that had little or nothing to do with the artist's emotional state, but addressed the viewer directly, dispassionately. His business was not to bare his soul but to make interesting paintings. To that end, Stella examined in basic terms what really happens to paint on canvas.

Since 1961, Stella has repeatedly explored the possibilities inherent to a formal composition of concentric squares, either single or paired. Always the challenge is to animate the static simplicity of the structure. *Double Scramble,* dating from 1978, is one of the later and more complex variations on the "Concentric Squares" theme. The title acknowledges the eye-boggling spatial play at work in the picture. Stella's subtle modulation of hot, warm, and cool colors incites a rhythm of measured pulses, creating powerful illusions of projecting and receding space. However, the spatial cues are inconsistent and sometimes contradictory. This confusion is effectively doubled by the duality of the image, each half behaving differently. Attention thus returns to prosaic reality and the flat surface of the canvas. For all its calculation, the painting does not read as a mechanical exercise. The edges of color are not sharp but finely brushed, leaving the thinnest margins of white canvas to separate the squares. Stella's evident craftsmanship underscores his intention: that the painting is a painting; nothing more—or less.

25

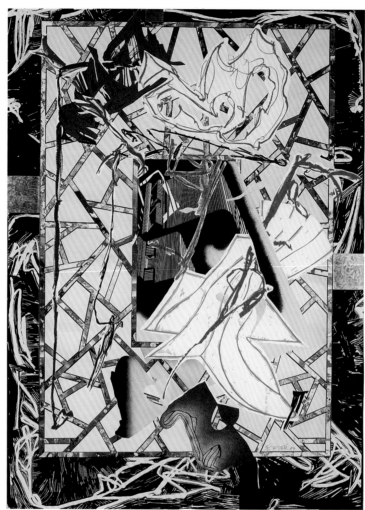

©Frank Stella/Artists Rights Society (ARS), New York, NY Photo: Steven Sloman

25.

Frank Stella

American, born 1936

The Counterpane

(from The Waves series), 1989

Screenprint, lithograph, and linocut, with
hand-coloring, marbling, and collage
Sheet and image: 71 x 51 in.
(180.5 x 129.5 cm.)
Published by Waddington Graphics, London
Edition: 15/60

REF.: Haskell 1997, listed 55, illus. 42.

Confounding the critics who thought his art had devolved into a monotony of geometric variations, Stella reinvented himself as the vanguard artist of the modern baroque. By his analysis, the problem of recent abstraction was "its inability to project a real sense of space."[1] His answer was to posit a new and sophisticated mode of pictorial space: volatile, unpredictable, and contradictory, yet never capricious, always just, and often witty. The artist's exhilarating ideas found a perfect home in the print studio, where recent innovations offered myriad possibilities of experimentation. (In fact, the radical advances in printmaking technology and technique finally convinced Stella that he could make prints fully the equal to his paintings and constructions.[2])

The Counterpane is one in a series of thirteen graphic images inspired by Herman Melville's *Moby Dick*. However, the inspiration is not literal: one searches in vain for any direct references to the novel. Rather, the images in The Waves series convey something of the richness, complexity, and overarching ambition of Melville's masterpiece. In *The Counterpane*, space runs riot in and out of the torn patchwork of a plane (suggestive perhaps of a quilt or counterpane).

1 Frank Stella. *Working Space*. Cambridge, Harvard University Press, 1986, p. 46.
2 Pat Gilmour. "Kenneth Tyler: A Collaborator in Context." *Tyler Graphics: Catalogue Raisonné, 1974–1985*. New York, Abbeville, p. 21.

{54}

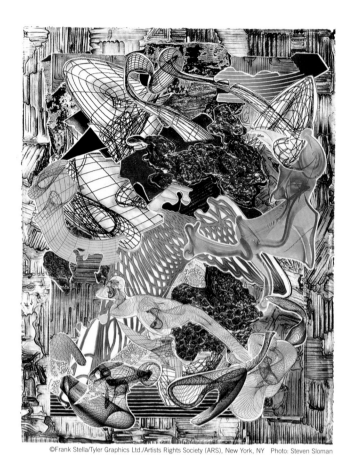

26

©Frank Stella/Tyler Graphics Ltd./Artists Rights Society (ARS), New York, NY Photo: Steven Sloman

26.

Frank Stella

American, born 1936

Fanattia (from Imaginary Places
series), 1995

Etching, engraving, relief, lithograph,
stamping, woodblock, and mezzotint
Sheet and image: 54½ x 41 in.
(138.4 x 104.1 cm.)
Published by Tyler Graphics Ltd.,
Mount Kisco, New York
Edition: A.P. 10

REF.: Sidney Guberman, *Frank Stella:
Imaginary Places*, Mount Kisco, New York
Tyler Graphics, 1995, 26–27, illus.
EXH.: JIA 1998.

Even more effusive than
The Counterpane (cat. no. 25)
is *Fanattia* from a later series of
eight virtuosic prints, each titled
after a different fantasy island in
The Dictionary of Imaginary Places
(1989) by Alberto Manguel and
Gianni Guadalupi. Here, the
various swirling forms, many
of them derived from computer
models of smoke, are cut out and
collaged in a delirium of knotted
and contorted space—a rapturous
response to *horror vacui*.

CITATIONS FOR RUNNING QUOTES

(1) Piet Mondrian. "Natural Reality and Abstract Reality," reprinted in condensed form in Michel Seuphor (Ferdinand Louis Berckelaers), *Piet Mondrian: Life and Work*. New York, Abrams, 1956, p. 142.

(2) "Text for catalogue of *documenta 7*, Kassel, 1982," in *Gerhard Richter: The Daily Practice of Painting: Writings and Interviews, 1962-1993*. Cambridge, MIT Press, 1995, p. 100.

(3) Stephanie Terenzio, ed. *The Collected Writings of Robert Motherwell*. New York, Oxford University Press, 1992, p. 149.

(4) Yves Michaud. *Joan Mitchell: New Paintings*. New York, Xavier Fourcade, 1986.

(5) Henry Geldzahler. "Interview with Helen Frankenthaler." *Artforum* 4 (October 1965), pp. 36-38.

(6) Frank Stella. *Working Space*. Cambridge, Harvard University Press, 1986, p. 74.

(7) Kirk Varnedoe, ed. *Jasper Johns: Writings, Sketchbook Notes, Interviews*. New York, Abrams, 1996, p. 93.

(8) "Notes, 1973," in *Gerhard Richter: The Daily Practice of Painting: Writings and Interviews, 1962-1993*. Cambridge, MIT Press, 1995, p. 78.

(9) Peter Halley. "Notes on Abstraction." *Arts Magazine* 61 (June/Summer 1987), p. 39.

(10) Nancy Grimes. "Al Held: Reinventing Abstraction." *Art News* 87 (February 1988), p. 109.

(11) Paul Taylor. "Roy Lichtenstein." *Flash Art* no. 148 (October 1989), p. 89.

(12) Frank Stella. "The Pratt Lecture," in *Frank Stella: The Black Paintings*. Baltimore, Baltimore Museum of Art, 1976, p. 78.

(13) Ellsworth Kelly. "Notes of 1969," in *Ellsworth Kelly*. Amsterdam, Stedelijk Museum, 1980, pp. 30-34.

(14) Calvin Tomkins. *The Bride and the Bachelors*. London, Weidenfeld & Nelson, 1965, p. 231.

(15) Kirk Varnedoe, ed. *Jasper Johns: Writings, Sketchbook Notes, Interviews*. New York, Abrams, 1996, pp. 19-20.

(16) Gerald Nordland. *Richard Diebenkorn: The Ocean Park Series: Recent Work*. New York, Marlborough Gallery, 1971, p. 10.

(17) G.R. Swenson. "What is Pop Art?, Part I." *Art News* 62 (November 1963), p. 25.

(18) Nancy Grimes. "Al Held: Reinventing Abstraction." *Art News* 87 (February 1988), p. 108.

(19) Jan Butterfield. "Sam Francis: Time an Infinite Number of Faces." *Sam Francis*, Los Angeles, Los Angeles County Museum of Art, 1980, p. 14.

(20) Peter Halley. "The Eighties and Jewishness." *New Art Examiner* 24 (June 1997), p. 30.

(21) G.R. Swenson. "What is Pop Art?, Part I." *Art News* 62 (November 1963), p. 63.

(22) "Diebenkorn, Woelffler, Mullican: A Discussion." *Artforum* I (April 1963), p. 27.

(23) Paul Gardner. "When is a Painting Finished?" *Art News* 84 (November 1985), p. 94.

(24) Dan Hofstadter. "Profiles: Richard Diebenkorn." *The New Yorker* 63 (September 7, 1987), p. 66.

Acknowledgments

Working on this exhibition has been a great pleasure and not only because of the range and high quality of the art. There was also the collector. Though The Haskell Collection is a corporate collection, it is wholly the creation of one man's passionate and discerning vision. I am grateful to Preston Haskell for so generously sharing that vision with me.

Primary research for the catalogue entries and the quotations was diligently carried out by David W. Wood. Mr. Wood drafted the texts for the entries, which I have subsequently revised and expanded.

Windi Kapugia, assistant to Mr. Haskell, ably and cheerfully served as liaison with the Museum.

Several members of the Museum's staff deserve kudos: Assistant Conservator Noelle Ocon examined the works to be exhibited and made useful recommendations regarding framing and shipping; Registrar Carrie Hedrick organized the shipping and tour arrangements; Librarian Natalia Lonchyna ably assisted with research; Chief Designer Eric Gaard worked his usual magic in the installation; and the catalogue benefited from the critical eye of Publications Manager Viki Balkcum, Associate Director of Education Rebecca Martin Nagy, and Head Graphic Designer Barbara Wiedemann.

JOHN W. COFFEY
Chair, Curatorial Department
Curator of American and Modern Art,
North Carolina Museum of Art